Praise for *The Artist and the Lava Beast*

"The tone of Mackavey's gentle, lyrical prose effectively complements the pastels that illustrate each stage of the painting's creation. The transition from the expected to the unexpected is smooth and intriguing; she makes every color and element of the painting its own character and elicits just enough reader concern for the fates of the fish and the houses without being too frightening. She also avoids being too literal when depicting the lava beast, showing just the head of the lava flow in swirls of brownish red oil pastels. In the text, the beast becomes sympathetic—lonely, scared and unsure of himself. He longs for the houses' cozy, well-lit interiors and eventually comes to rest, cooling finally into rock against the edge of the village."

- Kirkus Review

"A lava beast becomes the catalyst for a tale about learning to accept natural developments. The beast—destined to be transformed from an energetic force into a cooled rock—learns to embrace change, not with resignation but with a sense of belonging. In Maria Mackavey's *The Artist and the Lava Beast,* the theme of transformation offers potential teaching points for children who have embarked on chapter books with deeper subjects. Secondary themes of courage and acceptance are briefly touched on through a lone fish, who faces the lava beast."

- Foreword Clarion Review

"*The Artist and the Lava Beast* is a whimsical picture book featuring an artist interacting with his canvas. As the book opens, the artist stares at a blank white canvas and "wondered what he was going to paint today. What colors, creatures, stories would emerge as he picked up his oil sticks and applied them to the empty canvas…." While a lesson in the power of imagination, this book also aims to teach children about unusual colors. In the text, adjectives describing color are written in their respective shades. Standard words such as "pink" are represented alongside "mauve" and "lemon yellow.""

- BlueInk Review

The Artist and the
Lava Beast

by
Maria G. Mackavey

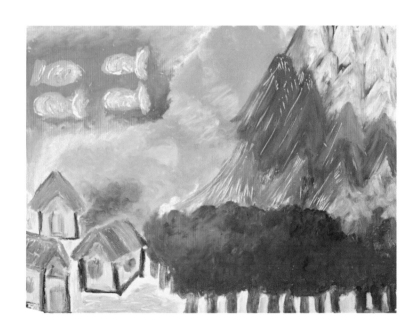

AuthorHouse™ LLC
1663 Liberty Drive
Bloomington, IN 47403
www.authorhouse.com
Phone: 1-800-839-8640

Published by AuthorHouse 02/11/2014

ISBN: 978-1-4817-2078-6 (sc)
ISBN: 978-1-4817-2081-6 (e)

Library of Congress Control Number: 2013903794

Any people depicted in stock imagery provided by Thinkstock are models,
and such images are being used for illustrative purposes only.
Certain stock imagery © Thinkstock.

This book is printed on acid-free paper.

Because of the dynamic nature of the Internet, any web addresses or links contained in this book may have changed
since publication and may no longer be valid. The views expressed in this work are solely those of the author and do not
necessarily reflect the views of the publisher, and the publisher hereby disclaims any responsibility for them.

authorHOUSE®

For

Lily, Alec, Jonathan, Noah, Aloha

Timothy, Ursula, William, Rose, Amalia

and their parents who read to them

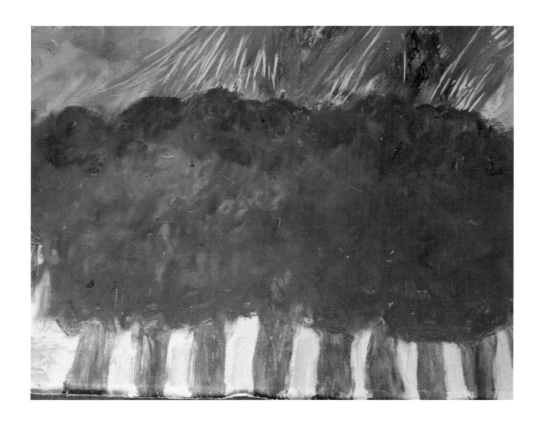

The Artist and the Lava Beast

One fine morning in late February, an artist sat on a tall, three-legged stool in front of his easel. He stared at the large white canvas propped up in front of him and wondered what he was going to paint today. What colors, creatures, stories would emerge as he picked up his oil sticks and applied them to the empty canvas.

He looked down at his box of oil sticks and picked out a bright lemon yellow oil stick. He began to rub the whole surface of the canvas with this color. He enjoyed moving the stick over the whole canvas in long and unhurried strokes. He loved the cheerful and friendly yellow color of this oil stick. It reminded him of the early spring day outside.

From his window, he could see the warm sun had melted the snow and he could hear the birds noisily feeding at the feeder hanging outside the window. He knew it would get cold again, but today he was happy to see the sun and hear the chirping of the birds outside.

He put down the yellow oil stick and stared thoughtfully at the lemon yellow canvas in front of him. He looked down at his box of oil sticks and picked out a mauve oil stick and began to color the middle of the yellow painting with it. Soon he was mixing the mauve with a silver gray oil stick and an orange oil stick. Using his finger, he rubbed the mauve, gray and orange paint together. As he mixed the three colors with his finger, big orange, cloud-like shapes began to emerge and roll down the center of the painting, like hot lava flowing down the sides of a volcano.

He picked up a green oil stick and drew circles with the green stick. A group of treetops formed in the bottom of the painting. He then used two different shades of brown to paint the trunks of the trees.

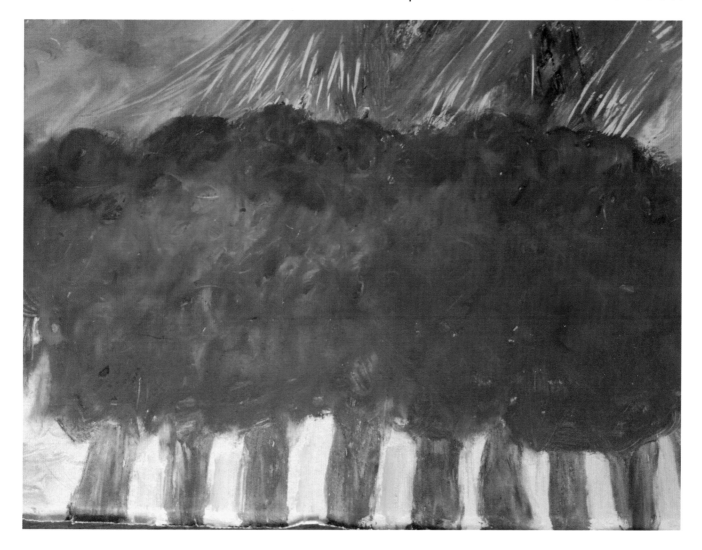

The artist paused a moment to look at what was shaping up on the canvas. The trees stood happily against the lemon yellow background, although they let him know they felt a bit cramped standing at the bottom corner of the painting. The artist ignored them and continued working on his painting. He colored in the yellow spaces showing between the tree trunks with an orange oil stick.

He then selected an aqua oil stick. He began to rub his oil stick back and forth until he had filled in the whole area at the top corner of the canvas.

He began to paint four fish in the aqua space. He applied pink and silver gray paint to each of the fish and then carefully scratched curved lines into the layers of oil paint with his fingernail. The yellow color with which he had started the painting came through on the oval bodies of the fish.

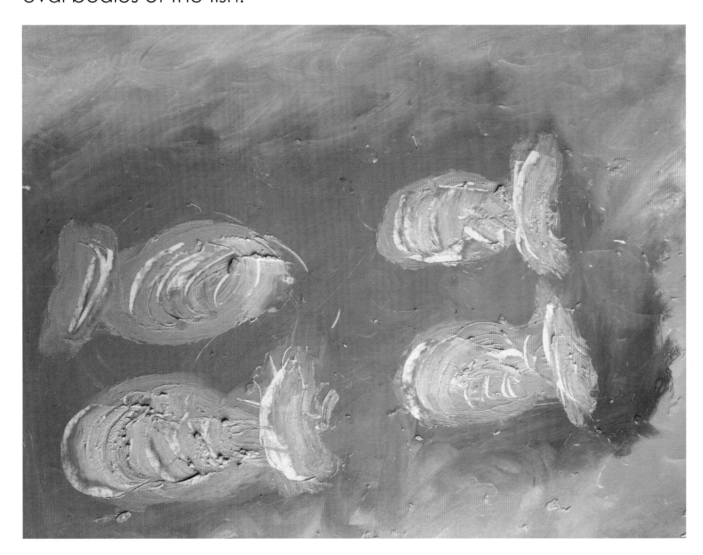

Staring at the four fish, the artist noticed that the four little fish looked shy and nervous swimming in the aqua blue water. Three of the fish were swimming away from the center of the painting as if someone or something was frightening them.

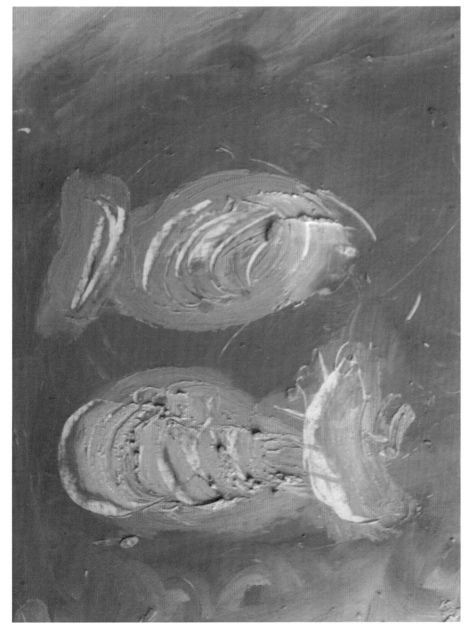

One little fish was different. She was not trying to leave. In fact, she was curious to see what was spilling into the aqua blue water. It was orange lava. The little fish tried to move forward, but her path was blocked by one of the other fish trying to get away from the orange lava. The little fish's dorsal fin beat back and forth in the water, trying to keep her from bumping into the other fish. There was confusion in the aqua blue waters of the painting.

The artist realized that if this little fish insisted on swimming towards the orange lava, she would most certainly get burnt. The scorching, smoking lava was now flowing down the middle of the painting into the aqua waters and into the valley below. The artist became afraid for the little fish, but the curious little fish seemed determined to swim towards the orange lava spreading into the aqua waters. Facing danger alone when your friends are swimming away takes courage, the artist thought to himself.

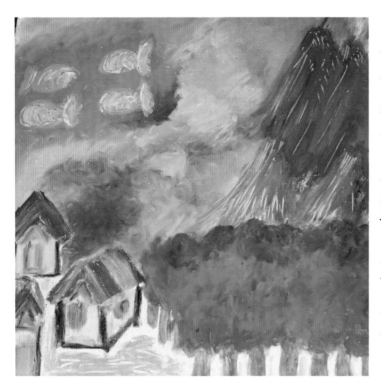

The artist was now worried for his whole painting. He followed the path of the scorching orange lava as it came down the middle of the painting. It moved towards three houses the artist had just finished painting at the bottom of the canvas. One of the houses was in danger. The lava was also moving closer to the green forest of trees that stood beside the houses.

The three houses were painted pink and had fire red roofs that had the shape of an upside- down **V**. The thick black lines around the corners and edges of the small houses made the houses look strong and brave.

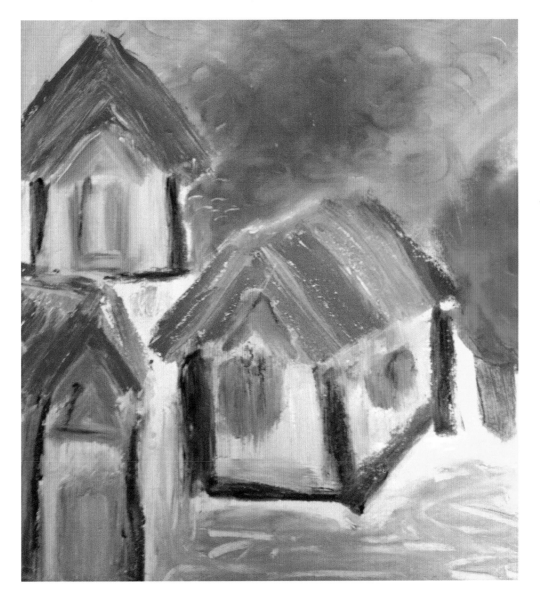

The three houses stood close together. Two of the houses looked as if they were closed up and shut down. Their gray shuttered windows had no light in them. But one of the houses stood alone. It faced out and the front door was open. A warm golden glow came out of the open doorway.

The artist liked to look at this house with its red roof and upside-down V-shaped roof. He used a soft gray oil stick to fill in the space above the doorway.

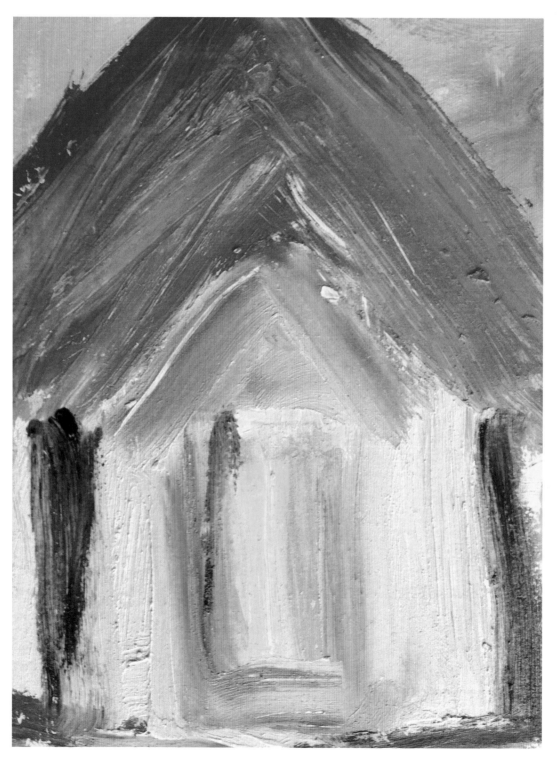

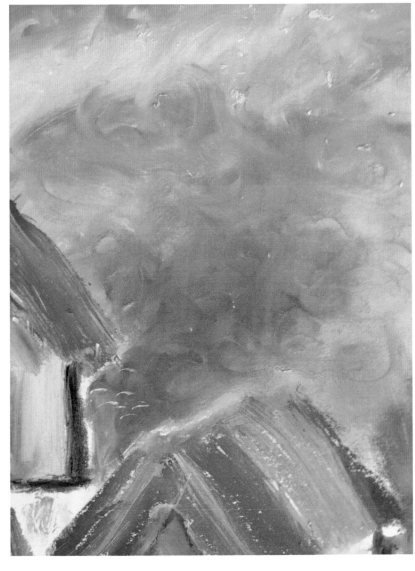

Then to his amazement, the artist watched as the orange-colored lava flowing into the valley changed into the smoky brown head of a giant lava beast.

The little house standing alone with its open door seemed unaware of the danger nearby. The head of the lava beast had crept up very close to the house and seemed to be sniffing along one of its walls. And yet the little house remained open, warm, and inviting.

The artist wondered worriedly whether the thick black paint he had used to make the pink house strong would be able to protect it from the scorching lava beast creeping into the neighborhood.

The lava beast had set out on his journey down the middle of the painting full of energy and enthusiasm. He had rolled and flowed and oozed his way down the side of the mountains. He had scorched and burned and singed grass, bushes and trees along the way. Nothing could stop him, not even the aqua blue water he went through at the start of his journey. The lava beast had fun scaring three little fish in the aqua blue water. He had tried to scare a fourth fish, but to his surprise, this little fish would not turn around and flee from him, the way the other three fish had. The lava beast did not have time to stop and check out this little fish as he continued merrily on his way towards the valley.

But as the lava beast approached the valley, he began to feel different. He was beginning to lose steam. After rolling and flowing and happily scorching his way down the middle of the painting into the valley, he was no longer feeling himself. The long journey into the valley seemed to have taken the fire out of him. His body was beginning to feel thick and heavy, and he was no longer rolling and flowing and oozing along. He was moving slowly, and he was starting to feel very cold and tired.

The lava beast felt scared and unsure of himself. What was to become of him now that he no longer rolled and flowed and burned everything in his path, as he had done on his way down into the valley? You see, he did not know that hot scorching lava eventually cools down and turns into cold gray rock.

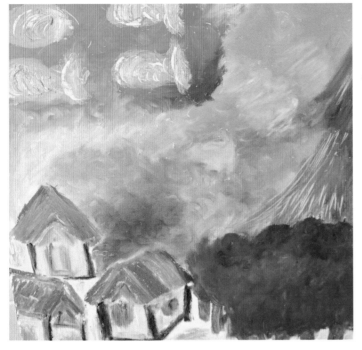

*H*is snout moved gingerly along the side of the little pink house in the valley. The inviting glow of the open door and the warmth coming from the little house attracted him.

*T*he lava beast wished he could enter the doorway and find comfort inside the little house with its warm fire. But his huge size made this impossible. He rested his large head in the valley and snuggled as close as possible to the little house so that some of its warmth would reach him through the walls and comfort him. He listened to the sounds of people talking and laughing inside the little house, and he drifted off into a deep sleep.

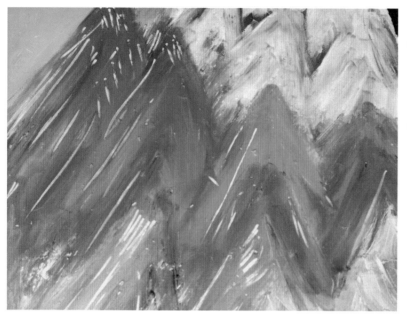

He dreamt he was in a forest – not a forest of trees, but a forest of mountains – endlessly climbing up above the little house in layers of purples and blues and finally snow capped, rising like giant fir trees into the sky. He was amazed by the grand and tall mountains. After all, there was not much in this world that was bigger than he was.

The blue and purple tops of the mountains closest to him had little streams of gold running down their sides. The golden streams made the mountains appear lit up from within by a deep golden fire. He lifted his big head and approached them slowly. He did not want to frighten them, as he had frightened almost everything he had come across in the past.

The mountains continued to tower majestically over his head, their

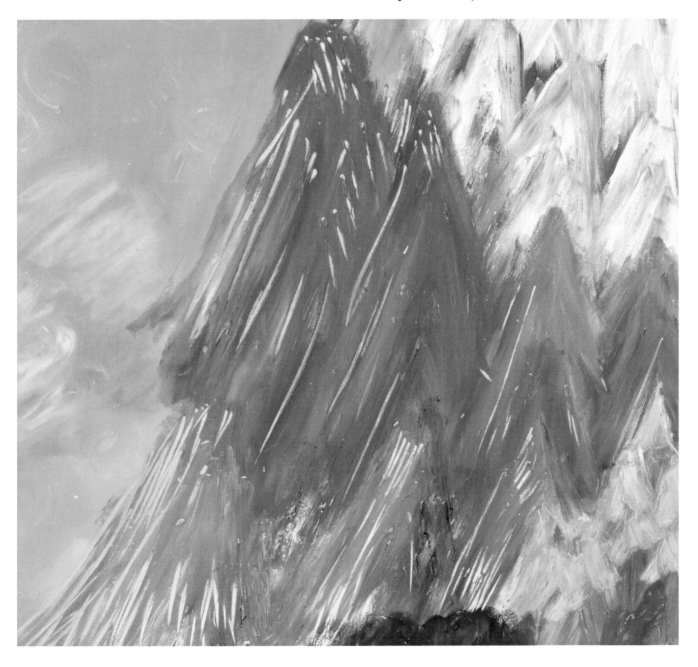

golden glow growing brighter. As he brought his head closer, a voice like sparkling blue glacier water rang from the depths of mountains and addressed the lava beast:

"What are you doing here, lava beast?"

The startled lava beast looked around him. Seeing no one, he said

nothing. He lowered his head and the silence around him echoed through the crags and valleys of the mountains.

The voice rang out again, but this time more softly:

"Do you not know where you are?"

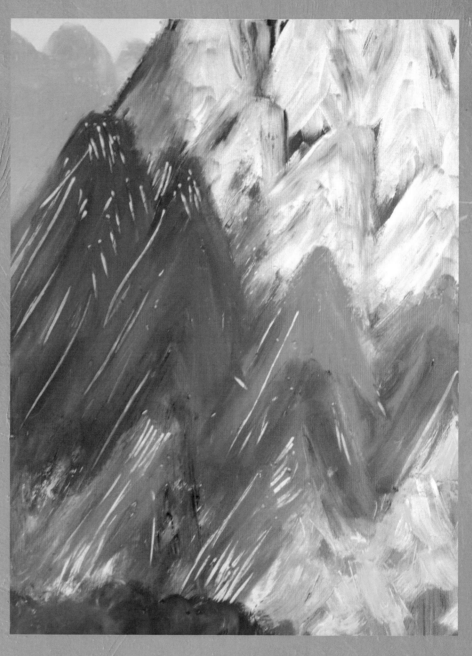

Once again, lava beast hung his head in silence. Now he was silent because he was sad. He did not know where he was and he thought he should. His sadness slid into the nooks and crevices of the mountains near him.

Suddenly, out of the silence arose a sound created by hundreds of voices humming as one voice. The humming began to float around his head. It seemed to come from the golden streams running down the sides of the purple and blue mountains. The lava beast slowly lifted his head and listened.

Something was happening to him. A fountain of fire was unfolding in his heart. It began to spread throughout his tired and cold body. He felt a deep sense of joy pour out of him and flow into everything around him – the towering purple mountains, the green forest beneath him, the fish in the blue water above his head, and most of all into the humble little house in the middle of the valley. He began to hum and as he hummed the earth filled with the fragrance of cinnamon and roses. His mouth overflowed with golden honey and saffron. The lava beast no longer felt alone and scared. He knew he belonged in this world of mountains, forests, fish and people in houses.

"Ah, lava beast, you are home," the voice told him gently. "This is where you belong -- with the mountains and the trees, the oceans and the fish."

"The golden glow you see on the mountains around you," continued the voice, "is molten rock that is called magma. You were born here in the mountains and one day you burst out of the mountains into the painting and became the lava beast. And now you have returned home."

As the voice faded away, the lava beast woke up and opened his eyes. He lifted his head and dreamily looked around him. Everything was still the same. The doorway of the little house was still open; its warm glow still comforted him. Someone inside was humming. The lava beast sighed contentedly and fell back to sleep.

Meanwhile, in the artist's studio, the purple oil stick fell out of the hand of the dozing artist and woke him with a start. He opened his eyes, yawned, and leaned down from his stool to pick the oil stick off the floor. As he packed up his paint box, he began to hum. He stopped packing and once more looked at the painting: The four fish, the trees, the three little houses, the mountains and the smoking lava were all there. He smiled as he remembered his dream.

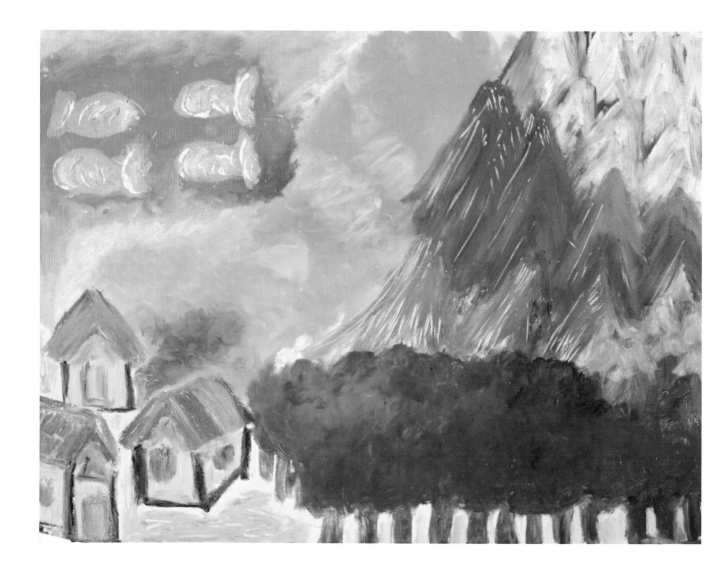

Quietly, he shut the lid of his paint box and walked to the door. As the artist turned the handle of the door to let himself out of the room, he heard himself softly humming a familiar melody. He stopped to think where he had heard it before. And then he remembered: it was the melody the lava beast had hummed in his dream beside the little red house.

THE END

CPSIA information can be obtained
at www.ICGtesting.com
Printed in the USA
LVXC02n1422200314
378253LV00018B/88